Just Four Words
Based on a True Story

Just Four Words

Based on a True Story

BY DEE CHRISMER

StoryTerrace

Text Dee Chrismer

Design Story Terrace

Copyright © Dee Chrismer

First print February 2022

StoryTerrace

www.StoryTerrace.com

Dedication

"This book is dedicated to Mum and Dad in heaven, who gave me the strength and courage, and were looking down on me.

And it is a tribute to Kate, the only one who could really have understood."

CONTENTS

1

TREMORS

At first, I didn't know where to start.

My story is big and sprawling. It has so many scenes that will shock, so many tendrils of emotion and consequence that stretch out from its astonishing core. It wraps people in its grip, my story – good people who love me, and one terrible person who I have flung away so that I can get on with my life.

As I looked at my story, preparing to get it down on paper, I had to find the point on its winding, lurching length where I would begin. There was no choice but to settle on a place and a time, but there was so much to say.

I picked London, and March 20th 2015. I took myself back to a single night of music, love and dancing. I chose the moment when I stood on the edge of a cliff, barefoot and happy in the long grass, with no idea that a terrifying drop was just in front of me, an abyss only a few inches away from my toes, its dark floor and dangerous waters a long, long way down, invisible in the mist.

It was hard to choose at first, but this moment seems like the calm before the coming of a tornado that picked me up, battered me with debris, and dropped me again.

So here goes …

Phil and I didn't argue, as far as I can remember. It was still a fun, romantic relationship after six years of marriage. Some relationships stale quickly, but this one felt great. We treated each other to things and we liked to go abroad and to concerts, to meals out and on trips. He'd bought me tickets to Chic at the Camden Roundhouse for that night of March 20th and I thought I'd burst, I was so excited. There's a photo of me back stage after the show, standing beside Nile Rodgers. The man's a musical genius, so it was a dream come true to meet him, as well as immersing ourselves in those sounds. I have the photo on my phone. In it I can see the thrilled and spontaneous smile of a woman meeting her idol. My face shows a woman who knows just how lucky she is, standing there during a wonderful evening, alongside a husband she loves.

Phil was going to Las Vegas the day after the concert, and I did not want him to leave again. He had been spending a week or two in every month in the US on a TV contract since the beginning of 2014, and I had begun to hate his business trips. But that was the way it was: he had a business to run and earning a living was earning a living. I'd done his company accounts for five years, giving up the role less than a year before to go back to the flying I loved, so I knew the demands of a busy company. We stayed in a hotel that night and I left Phil at Heathrow the following morning,

feeling very low, really as though my heart was breaking. It was an empty, lonely sensation as I went to the train station after such a lovely night. A terrible sadness gripped my heart.

But we have to go back to the time before this, and to a gut feeling. Gut feeling. It's one of those phrases that does its descriptive job; we all know that slight churning in our stomach when something is not quite right. It's an emptiness, a tiny sliver of worry, a hint of grief. It settles quickly and we forget it, until … there it is again.

It was January 2014 and I was off to Barbados with my friend Cara for a week. Cara's been a close friend for nearly 20 years, since we did a flight together and 'clicked'. I found out that she lived near me, offered her a lift home and then a glass of wine. Ten hours later we were still there, talking! She talks as much as I do and she's got a great sense of humour.

Cara was working for an airline that flew the Barbados route. She was allowed to book a holiday flight for herself and use a 'jump seat' – that's a free space for a friend. Phil had urged me to take a well-deserved break, catch the sun, spend time with my friend. But on this occasion no jump seats were available. Cara could have taken me with her another time, but Phil insisted on giving us the necessary £1500 so we could spend New Year in Barbados. Cara told me later how surprised she was at the extravagant gesture.

Just before leaving, I found a receipt in the room that his daughters shared. Phil had two children from his earlier marriage and they stayed with us regularly. I didn't recognise the shop on the receipt so I Googled it, and discovered that he'd bought some sort of slutty outfit. I asked him about the purchase and he said,

11

"Oh, I got that for you, but then I thought you might not like it." He smiled his charming smile. "So I took it back," he said with a shrug that indicated, *it's nothing, don't even think about it.*

I watched his shoulders rise and fall in that shrug and I willed it to be so. I think that every wronged person wants the lie to be the truth, at the start. It's natural. I was a natural person and I still am. I'm drawn to people who are warm, and true, and loyal.

Usually.

That was the first of the beads of worry that began to collect. The receipt made me stop in my tracks for a second and feel … well, how *did* it feel? It was the floor shifting slightly under my feet – just the hint of an earthquake that might (or might not) hit.

A statement arrived in the post one day, addressed to Phil. He and I shared our finances, and all our accounts and cards were in two names. There was no reason on earth not to share everything, so there was obviously no reason not to slit open the envelope. I saw a name on a credit card application, a woman's name. I spoke to him about that, too. He said that he needed to get a company credit card for a member of staff at work.

"You trained her, remember?" he said, waiting for me to catch up, his expression patient, "after you left my company? Yeah?"

I *did* remember a woman at the company with that same first name, and I *had* worked with her.

Phil shook his head, a little exasperated, but not at me. "The bank must have got mixed up," he said.

It is hard to explain to someone who has not been in this particular situation, why it is that a wife wants to believe, and why

she persists in believing. But remember all that had gone before - remember the love, the history, the shared life.

He took the statement away and I carried on with my day, but my thoughts nagged at me: nobody can apply for a credit card in someone else's name; banks don't make mistakes like that. I know how banks operate because of the work I did for Phil. But I let the unease settle and my stomach stop its almost indiscernible churning, and I carried on.

The earth tremors grew stronger - little shudders refusing to fade for good. Small pieces began to fall off me, fragments of the Greek statue that is Dee, dropping to the ground with a tiny puff of dry dust. On the kitchen worktop I found an invoice. 'Aria Wedding Chapel, Las Vegas'. A five-figure sum.

"What's this? I asked him.

I could almost see the cogs of his mind turning, but I simply listened. There was going to be a perfectly good explanation.

"Oh, don't tell Jen!" he said. "It's supposed to be a secret. They're renewing their vows. It *has* to be a surprise."

Friends of ours had got married in Las Vegas, years before.

"Okay," I said. That seemed a lovely thing for them to do. And it was the explanation I wanted.

That day, I remember, we were out with our friends Sally and Neil. We'd known them for years. I mentioned the statement to Sally. I think I was casual about it, giving my fears a voice, but telling myself I was having a laugh. My husband, having an affair! As if! Now I know that Sally was anxious. She had been sensing something wrong, but she said nothing. Should I have listened to

her silence? I think we hesitate to give our suspicions voice because we don't want to hurt a friend, or damage a friendship. Phil was horrified – Dee even *saying* the word 'affair' – it was a shock. He dashed to the toilet and we could all hear him being sick. I felt terrible for allowing the thought into my head. *My God*, I thought, *if the idea of infidelity makes him throw up, I'm crazy, or paranoid.*

He is such a talented man. It's a pity his skills have been so wasted, and have been employed to hurt so many people. He ought to have an Oscar for deception on his living room shelf.

I found a wedding ring, and I asked him about that, too. You, my reader, will be seeing the pattern here; you will shake your head in disbelief and wonder how a perfectly intelligent person could not see it. But think of him, my husband who charmed birds off trees. He had a quick mind, something I understand far more now that I can see it in action across the years.

"It's Ed's," he said, again with the patient expression. "We were doing a job."

He gave details – the best tool in the liar's toolbox. He had offered to look after the ring while Ed worked on the electrical contract. I know what you're thinking: why would a man not put his ring in his pocket? How many jobs had Ed done with a wedding ring *on*? But I craved the reasons that Phil gave me. When you want something to be true, you will find a way to make it so. That is the power of human emotion, and the force of human fear.

But I was uneasy. Phil had got smarter, his clothes more stylish. He was changing before my eyes and I didn't know why. I suspected, deep inside me, that he was hiding something. He did

have to work away from home, but did he have to be absent so much, both in the US and UK? Those gaps of time were a hidden territory to me, and increasingly I was frightened of what I could not see. The idea of another woman came into my mind. Why wouldn't it? What partner or wife hasn't allowed that to creep into their consciousness? But at what point do they ask? What moment should they pick to stand facing away as they fill a kettle, and dare to speak that challenge aloud?

Now I have to circle back to March 2015 and Chic and that magical night. I'm reluctant to do it. There is a parallel universe in which I found out nothing, a universe in which my life was not shattered, nor were the lives of others. I've thought about that a lot: what if I had not finally guessed a six-digit password, and the truth had remained hidden, all those words and pictures unseen? Imagine me on the cliff, the recollection of those little earth tremors buried away somewhere in my head – the credit card, the chapel, the outfit, the ring, and the feeling in my gut.

I had begun to look for information. Sometimes I've said to a person listening to my story,

"God, do I sound like a stalker?"

They shake their heads – of course I don't – and I know that anyone in my position would have done what I did.

Phil's iPhone was synched with his iPad. He had been taking his laptop to Vegas and leaving his iPad behind.

In the end on June 2nd 2015, I got in. I had already tried several times to get access, which always felt weird. The tablet would sit there and I'd pass by and try a passcode, and then another. My

attempts would fail and I'd step back feeling … a little bit dirty? A tiny bit guilty?

Bloody hell, there's irony for you. Me, the guilty one?

In the end the password was the most basic you can think of – the year of his birth.

Sitting there, hunched on the edge of my bed with the small screen in front of me, I could see his life in words and pictures. But it was not the life I was familiar with; it was another one. Soon I was to discover that it was *more* than one other life.

It was an explosion of betrayal, pretence, pain and damage.

2

EARTHQUAKE

The rug was pulled out from under me, hard and fast. It's a cliché, but betrayal feels like that, believe me. Yank, topple, flail, crash. The pain, the sudden lack of air in the lungs. The nausea, the beginnings of the bruising as you land - a mess on the floor with your blouse rucked up and the tears coming. Shock attacks you in a hundred ways.

Here's his iPad in my vision, the colours of its screen smudged by a sheen of fingerprints. I see a photograph of a woman in a kitchen. She wears a tight, baby pink dress with a low V-neck. The cleavage on show seems to fill the frame as I stare at fake tan, red-eye, her hand on a work surface, pale nails tapping the marble. On her long face, below a mane of ash-blonde hair, is a half-smile. A come-on.

Time slows, or perhaps that's just a cliché, I don't know – already the events of those first minutes are starting to blur, and later I won't be able to remember exactly how my brain and body reacted. Straightaway the shock is flooding in – that's certain. I don't know, as I absorb that first image, that the confusion and panic will keep

coming for days, weeks, months. I don't know if it's ever completely faded, if I'm honest.

My brain tells me how easy it ought to be to identify this woman who is on Phil's device. It's synched with his phone, I think. I'm lucid and I'm drowning, all at the same time. Everything on here is on his phone, too.

The lucidity wins out for a moment, and I pick up my phone and start to take photographs of everything I am seeing. My intellect functions: this device may be shut down – it will be shut down and wiped, and with it will go this evidence. I have to capture it because there will be consequences. The word 'divorce' forces itself into my mind: I will need to show this stuff.

I feel I should work out who the woman is. She must be from work; or she's a person I know from somewhere else. Is my memory for faces deteriorating? I am scrolling, my finger starting to shake, and the shaking annoys me. There's a second photo, and this time there is my husband! His smiling, cheeky face is pressed against the woman's and her hand cups his chin as she nudges them both into the frame. Now she has a huge smile, all white teeth and eyeliner. In the next one they are crammed together again, half-naked, and I can see a pool behind them. This is a holiday that I wasn't on.

It's not the blonde who takes over my mind. It's Phil. He has lied to me. He has another woman. That statement's so simple, so … ordinary, taken from the script of a million TV dramas. It's not new, but my god, it's devastating. The anger that will become my companion begins to build and I scroll on. When I've taken a gulp of air, I read.

Ok beautiful. Dreaming of you last night.
Ha ha, really? Tell me all.

That's not me writing. It's nothing to do with me - not the mobile number on the header of the messages, not the words. My hand lifts and touches the top of the screen. I could close the tablet now and never look again, but the thought lasts a millisecond; it is someone else's reaction, not mine. Dimly I recall not wanting to know about the slutty outfit receipt, the credit card, the statement, the ring. Now I want, *want* to know. The dark mass builds, a heavy cloud bursting with rain.

My eye drops down the messages.

Romantic gushy stuff ... with some amazing hot sex thrown in.
I was really able to do anything with you.

There is nowhere else in the world I would rather be with than you.

Even just dropping me off, bringing me lunch, even just in that wee bar. I would kill for one of them weekends again.
I don't think I've ever been as happy as I was in London.

I feel sick. It's a thick, heavy nausea, but I don't allow it to take control, and I am picking up my phone because I know there's

something I can do to ease the shaking of the ground and the feeling that I'm going to fall into a chasm and be lost forever. Someone will help me stay upright as the earthquake peaks. The thought of my friends keeps the sickness at bay a little, and I take in air. They begin to parade past me, a Disney Fantasia line of precious men and women that I can laugh and cry with.

I keep scrolling, and then find another woman, and another fact – a fact so huge that it takes me what seems like an hour to absorb it. Now is the time for crying. Here's a new thread - long, and packed with words, emoticons, screenshots and photographs, so much that my eyes can't settle.

Can you promise we won't be apart for that long anymore?
I swear, baby.

Hey, my hot husband
Hi, love. Did you have a nice day?

There's a black and white photo of a woman who leans in towards my husband, big white skirt spreading on the floor, naked arms, a sphere of flowers in one hand, elbow crooked as she kisses Phil, his stubble tidy and his eyes shut.

I lean in too, mirroring them, and my mattress creaks. He wears the black suit of a bridegroom. More photos, the camera zooming in and zooming out. How many kisses was that? Was each photo a new kiss? In one image their lips have parted and their foreheads touch instead, smiles blissful as they stare at each other.

My breathing has stopped and my insides are heaving and buckling. I am looking at a wedding, and the aftermath of a wedding.

I haven't been around you since we got married.

I scan for dates - the end of March - only weeks ago. He was marrying another woman, that time he left for Las Vegas after the concert! It's impossible, and overwhelming, but it's there in black and white.

The wedding woman is ill. Phil sends messages about meds and hospitals. He's bought a company and she wants to know how. This is a couple's life, conversations about sex and love, work and play. There's a screenshot from him of a happy couple – stock photography with a schmaltzy quote: 'A happy man marries the woman he loves; a happier man loves the woman he marries'. Back she comes with another screenshot in tall black type - 'Best husband ever'.

I scroll and she comes into view, her face and long dark hair filling my vision. Perfect teeth, big smile, posing with her head propped in her hand.

I love you so much!!!!
I miss you so much!!!!

Words and images – pet dogs, breasts, wine glasses, his hand with a ring, endless love heart emoticons scattered across everything until I'm trembling and stunned and I don't know how much time

has passed. I gasp as there she is again, lying back, eyes closed, dark hair splayed behind her. He writes:

'This beautiful woman is Mrs W, my wife!!!!

Then there's Phil in the bridegroom suit with his hands clasped before him, smiling just as though he's shy. Two men are with him. I stare at Phil, delving into my heart to find out what I think and what I feel, right now, as the lies and the enormity of this seep into my consciousness. I wonder what will come: sorrow, regret, love? But it's fury I feel. He looks like an alien, nothing like the man I married.

A wedding cake scrolls by – I'm on automatic now, although each image still makes me gasp. Now they are dancing in a photo with a livid purple tint.

Are we gonna see the kids?
I'm not sure. I have that course, it might be tricky this trip.
I just don't want them to think I don't want to see them.

He is talking about his *children*, my step-daughters, and rage climbs in my throat like bile. How can he have even spoken their names to this woman, this fake wife who has never known them? They are dear to me; how dare she think she could mean anything to the girls?

On the messaging app the 'wife' has the name Richard, one of his business partners. He's thought of everything! If I see that name pop up on his iPhone, I won't think to investigate. The deviousness revolts me, the way he's hijacked a friend and colleague, for this!

It hits me that is he is over there in Las Vegas *now*, as I sit on the bed and uncover his treachery. My eyes drag themselves back to the messages.

> *Best Husband Ever!*
> *I ask myself every day: how did I get so lucky to marry my best friend in this world.*
> *2015, the year I married the most amazing man alive.*

I pity her, and that's a surprise. I hate him, and that isn't.

3

AFTER SHOCKS

Looking back at that moment on the bed, I smile at the first number I called and why I called it. Into my mind popped a barbecue I was due to go to that day, given by a guy from work. The plan was that I'd pick up Nora, an Easy Jet colleague, and we'd drive on together. It struck me as I sat with the iPad that I really ought to let her know I wouldn't be going. I'd probably give it a miss (despite the lovely weather) because my world had collapsed. Humans have a weird urge to get the practical things sorted. When catastrophe strikes there are still bins to put out, and when someone rips your life into small pieces, there is your diary to consider.

I had to find someone to cling onto. I thought of my sister, but she was on her honeymoon; telling her would ruin her happiness. Already I was laying down soft cushions, I think, to protect the people I loved. I thought of Miles, a newer friend but already a very close one, but he was flying that day.

So it was Nora that I called.

She said, "Don't be so stupid – of course he can't be *married!*"

But I had the iPad on my knee (and my phone in the other hand) and I could see it all in colour. Nora demanded that I get in a taxi (she didn't drive) and get myself round to hers immediately. We both focussed on Phil straight away, rather than on the other women he had lied to. That was to become my whole approach: it was about what *he* had done, and why, and how he could be so cruel. The other women were objects of pity, but in the background. As time went on, I was to have exchanges with a few of them, and I will write about those.

At first I hadn't the energy to think about the hints that should have told me he was a lying, manipulative bastard. But later I thought of a moment when the truth hovered before my eyes but I didn't see it.

Tenerife, 2012. I am with my friend Sally on a girl's holiday, on a balcony having a drink. I can hear the clink of ice cubes now, see the sunlight on the glass. Sally said she had something she had to tell me, something about Phil. She was frowning and I watched her face, feeling the globe judder slightly on its axis.

"Oh, *I* know!" she said, and she remembered whatever it was – a trivial thing she'd forgotten for a moment.

I burst out laughing, probably too loudly, making Sally turn to me.

"Oh my God! I thought you were going to say he's having an affair, Sal!" I said.

We've come back to that moment more than once, Sally and I. She has told me what she was thinking:

Oh, Dee, he probably is.

Neither of us wanted the idea to get out into the open.

How many other clues did I get? I don't know. Phil did electrical contractor work in schools and on one occasion, a year before, he told me in passing,

"By the way, there's a teacher who apparently wants to send me a birthday cake."

His face was twisted into a 'no idea what *that's* about' expression.

His assistant Serena had taken a call from this teacher, and he had learned that Serena had innocently passed the information to me. Now I know that Phil had seen trouble on the horizon. He was in some kind of a relationship with this teacher, or he had his eye on her, and he was heading me off at the pass.

"I don't know why she'd do that," he said, "send a cake!"

Later, Serena said that the teacher wanted to speak to me. We never did talk, and I wonder if she found out that the man she'd been flirting with had a wife. Perhaps she was hoping to reassure me that nothing had happened. It's funny really: even if *she* wasn't pulled into his ugly game, plenty of women were.

It has been hard to untangle the events of that day in June and the few days afterwards. I know it was the day after when I called Simon, my manager. I'm thankful that I'd given up working for Phil's company and was with EasyJet; I'd never liked the accounts work I did for Phil and I wanted to fly again. Now I can see that Phil edged me out by supporting the move. He was keen to get me

away from the business so that he could siphon off the profits and abuse his partners. But that's for later …

I called in sick, and company policy was that a manager made a quick call to check the member of staff was okay.

"So, *are* you okay?" Simon asked.

"No," I said.

He had a sixth sense and offered to visit. When he arrived I showed him the iPad. He knew about my friendship with Cara and said I should call her, and after that he made me book a doctor's appointment, concerned about my health and welfare. There and then he gave me three weeks off to mend, but I took only two because I began to need work. I told my colleagues the truth from the beginning, and that was typical of my journey back to strength, and my fight. I had been deceived; I would deceive nobody. I have also always known that sharing a problem will bring in the support a person needs. I felt myself healing in tiny increments as other people learned about my trauma.

Simon was a caring and unselfish man. The contrast between his behaviour and what I had uncovered about Phil was stark. Simon was the first in a long line of individuals who reminded me that most people are good; they get up each morning wondering how they can be useful. There's most people, and then there's people like Phil, who weave webs of lies, and hurt everyone they touch.

I know I called Cara quickly, but later I couldn't remember if that was the same day or the next. How many people passed through my house, how long did each of them stay, and did they overlap? What fascinates me is the way in which the mind can divide itself

into compartments: I was determined to use my anger, and fixed on the plan for taking my revenge, but at the same time I was lying in the rubble, my throat full of concrete dust and my feet trapped.

Cara drove up as soon as she knew. Simon stayed with me until she arrived - he was adamant that he wouldn't go until she was with me. Sally arrived but I can't remember exactly when. People were everywhere and I'm sure it helped, these loving humans with their tea and their hugs, the humanitarian aid swooping down on the earthquake zone. I didn't want to be alone, and I never was. Miles has since said that they were a tag team, arranging to be with me in shifts. Miles remembers going back and forth between my house and work. My birthday is June 8th and the mail brought cards and presents. Somebody piled them up; I guess we all knew to delay that celebration.

Slowly, slowly the dust settled, but with that came new earth tremors to knock me over. I could not get out of my head that I was one of a crowd. Can you imagine the humiliation of that? From being an adored wife, I had become one in a gaggle of women that he'd abused. How many do I actually know about, even after all the research I and my friends did? How many were there after our marriage, how many before?

A wife is a man's special person; a husband is a wife's one-and-only. A marriage should be your place of calm in life's storm. On June 2nd I had been expecting my man to come home and my life to return to its even keel. Suddenly that was gone. His intimacy and his affection were fake, and I was disgusted.

Miles has talked about the horror of sudden loss. His mum had died unexpectedly when he was 21, a year before I met him. One moment he was saying goodbye to her as she went to hospital; the next he was told that he would never see her again. My loss was different, but Miles and I can detect the aftermath of shock in each other's eyes.

The messages and images on the iPad continued to flow, and then when he landed at Heathrow he sent the same loving message to three women. Thank God, Cara was there beside me to absorb that particular shock. How can I describe what it feels like suddenly to become one of a crowd? I could not stop myself thinking back over other messages like it, and wondering if I had just been 'copied in'? Cara says that I was floppy at that time. The body goes limp with this level of trauma; I remember falling off a toilet simply because my skeleton seemed to have dissolved and I had nothing to keep me upright. Cara had to come in and get me out.

The images and words are still vivid, of course, and stored on the cloud in case I ever need them. I have always felt that the enormity of what hit me can really only be understood if the person I am talking to sees the evidence, so I have retained the digital paper trail. Without it, is all this hard to believe? Sometimes I can hardly credit that it happened, that one human can choose to do that much damage to another. It puzzles my friends too, and especially Alina, my sister. They could never cause that much pain themselves, and they can't fathom how somebody could.

But I know how real it is.

4

CLEARING THE RUBBLE

I didn't hesitate to call a lawyer. I wanted to get the ball rolling and be rid of Phil as soon as possible. As I was taking my first steps, I was aware that he had no idea I was preparing my own rug, to be pulled out from under him as hard as I could yank. There was a lot to do, and I think that kept me from collapsing in a heap. Alina talks about the difference between us. I'm the romantic – I give too much love when it's on offer (she tells me) and I often don't get the same measure of love back. But Alina also reminds me that I'm very strong. I don't look it, but I am the coper – in bereavement, for instance. She looks tougher but she's the one who folds.

I contacted Phil's first wife, mother of my step-daughters, because a sudden thought had frightened me: Danielle was working for her dad at that time, and one of my immediate motivations was to avoid the girls being hurt. I'm close to them: I left a job I loved at Thomas Cook partly so I could be at home more to care for them when they stayed with us. I was not just their dad's distant new wife; I was central in their lives and had a hand in raising them, even when Phil was absent. Working in Phil's business, and then flying

short-haul with Easy Jet was a way for me to give the girls what they needed. And yet Phil had done this to all of us.

So, I thought right away about Danielle, and called Phil's ex-wife.

"Can you keep Dani off work for the day?" I asked her.

I had a plan for the moment when he would walk into our home, and there would be fall-out from that. I wanted to shield Dani from that.

She agreed. The work had begun.

I composed a text and an email. The first was to go to Kate and Lara, the woman he had pretended to marry in Vegas, and the blonde in the other set of messages.

> *We have been married for 6 years, extremely happily (or so I thought). This morning I found out that he is (illegally) married to you, Kate, and also having an affair with you, Lara. I have proof and I bear no animosity to either of you.*

I offered a copy of our marriage certificate and a wedding photo. I'm pleased that I was measured, polite and straightforward; I was going to do this with dignity.

The email was to his colleagues, and I could send that because I knew them and had worked alongside them, believing at the time that I was helping my husband build our life together.

He was due home on Friday June 5th and Cara was with me that day. I was terrified of what I would say at the moment he walked in; it was like a black cloud swirling in front of me, unknowable

and frightening. So we got a black bin bag and attached images of the Vegas 'wedding' to it, harvested from the iPad. This served two purposes: I needed to have something to do with myself at that crucial moment, a way to show him that I knew what he'd done, without my vocabulary failing me. And *he* needed to understand right away, when he saw the bin bag, that I knew his revolting secret. I didn't want to be forced to explain. Into the bag went his clothes, too. I know that I sound like a woman scorned, like some character in a film who throws her unfaithful husband's belongings out of a window while the neighbours watch, scandalised. But I *was* a woman scorned, and these terrible men exist, and Phil is one of them.

I think I needed him to suffer because it might ease my own suffering. I needed, so badly, to feel less distraught.

I waited with the bin bag in the hall. Cara was with me, ready to help in any way.

"You only need to say four words," she told me. "*You need to leave.* Can you say four words?" She made it all clear. "If he doesn't get out when you tell him to, three times, I am going to put my head round the door."

What was my state of mind? I needed to get him out of my house and never see him again.

He came in. Behind the door, Cara pressed 'send' on the pre-composed texts that would condemn him. He looked at the bin bag and began to ask what I meant, feigning amazement. I did what Cara had told me – three times I said 'you need to leave', each time pointing to the bin bag. She was right - I only needed those four

words because my meaning was there in the images, plastered all over the bag.

Then Cara showed herself. Phil turned white, picked up the bag and took it with him.

He sat on the drive for half hour in his car. I think that was the longest half hour of my life.

Yes, there was triumph when I imagined those texts flying to their recipients. Yes, I was glad to have been clever, to have remained standing and to have got him. I kept that iPad trail open so I could see his actions. Importantly, I had wanted to make sure he was back on British soil before I showed my hand. He might have done a runner if he'd found out earlier. And yes, I wanted this to be as unpleasant for him as I could make it. I didn't love him now, and that was a surprisingly easy 'off' switch to flick, because he was a fake. He *is* a fake. He is not the person I married. Instead, he is a skilled liar who puts his energy into selfish gratification and doesn't care what he does to others.

My birthday slid past unmarked, but (unbeknownst to me) Miles already had that one under control, which is no surprise when I think of it now. I met Miles when we were both working for EasyJet in 2014, and knew immediately that we'd be best friends because he had the kind of sunny personality that's so attractive to me, and a kindness that shone out of him. It was another birthday that first brought us together, in fact: I was working a late flight on my birthday and he had a short early one. He offered to swap so I could enjoy my birthday, and I was home by midday! If you've ever worked shifts you will know how much that's appreciated.

Observing me in those first days after I found about what Phil had done, Miles did the kind of thing he does, the thoughtful thing. He began to arrange a delayed barbecue.

"You're having your birthday now," he told me firmly, when we celebrated.

That was how it was with my friends: they took things in hand as the time passed, they moved in on me, they acted. There are the people who prop you up when it looks as though you might fall, over and there are those who give you a slap, shove you into the dirt and walk away.

My sister returned from her two-week honeymoon and it was Cara who told her the news. She was upset. How could I keep something this terrible from her? She hated not being there for me, but why ruin someone else's joy because your happiness has been stamped on? Alina got it, though – she understood the state I was in. To wade through it all again with my sister at that moment – it was too much.

It was a time of numbness and shock as I moved through the rubble, everywhere seeing new regrets and reasons to be miserable. When your surroundings come tumbling down, you grasp at every reminder of the things that have been taken from you. Turning each corner, you see something else destroyed. I didn't cry; I don't remember tears as those first weeks unfolded. I was practical, almost stepping outside my body and becoming an automaton with a strength I'd never known before. It was almost, too, as though my mum and dad were looking down at me from heaven, protecting me.

5

REBUILDING BEGINS

Cara was on leave because she was pregnant, and she suggested taking me to her mum's in Ireland as an escape. But I had things to do before I could rest. My finances were tied up with Phil's, and I realised that I had to get access to my own money. God alone knew what he'd try.

In the joint account that I shared with Phil was the residue of an inheritance following the death of my parents. I had seen it as joint money: I'd used some to create a new driveway; Phil had used some for the business. I didn't consider an individual account because he was my husband, the man I loved, for richer, for poorer.

Cara was very concerned that Phil would get to the joint account and screw me over some more, and she advised me to access the account myself. I had to stop him in his tracks as soon as possible. We were correct in our suspicions: at the bank branch I was told that the password had recently been changed. The member of staff asked me if I could tell her the new password. When I look back at this particular incident it's hard to believe it happened, but Cara and I are sure it did. Since then, I have tried to find out if bank

staff are trained in helping wronged partners in trouble, but there's nothing to suggest they are.

"I suppose you use one of the daughter's names?" she said, looking directly, significantly, at me across her counter. I frowned back, trying to work out what was going on, but she just waited, neutral and calm.

"Just a name …?" she said.

I gave her one of the girls' names and her eyes moved to her computer screen, her fingers flew on the keyboard.

"Thank you," she said, just as though she was paying in any old cheque.

"And finally, I just need a reason why you'd like to withdraw the full amount," she said with the same direct gaze.

I opened and closed my mouth.

"Any reason," she said gently, her hand suspended over the keyboard.

I think I said I wanted a holiday. My God I did, so there's an irony!

So I got the ten thousand pounds that were still in the account and which he thought he'd locked away from me. It was my money, after all – my sister and I had shared the legacy and that was where my share had gone. I sometimes think of where I'd be financially if I had never married him. Potentially, I'd have a whole lot more that he took from me during our marriage and afterwards as he wore me down in an endless divorce. Phil lives in luxury now, and I can be sure that part of his lifestyle was funded by me. Somewhere he has my collection of vinyl records, and the precious Irish

silverware that Cara gave me, beautiful decorations each year, for my Christmas tree.

The next problem was where to put the funds. The night I withdrew them, I stashed them under the mattress! Cara had to remind me later that I did that; I suppose some crazier parts of a story get drowned out by others. I had no bank account of my own. I would never be in that position now and Jason, my wonderful partner, is fine with my financial independence. Cara offered to keep the money for me until I had a personal account, and I had no hesitation in trusting her. I rejoice that I had friends I could rely on absolutely, when trust in my husband was shattered. I remember going into Cara's bank with her. Neither of us had handled a sum of cash anything like as large this. The teller smiled.

"You are *really* wanting to get this into your account, aren't you!" she said.

The money under the mattress reminds me of other frantic measures I took. Sally carried my valuables and passport back to her place for safekeeping. It sounds paranoid, but I didn't know what would be coming at me next. I had visions of Phil entering the house, arriving from wherever he was hunkering down in Essex and doing … God knows what.

Phil and I were booked to go on holiday to Ibiza that July. I used my airline privileges to change the name on his seat to that of my friend Rebecca. Rebecca's been a best friend since my Bristol childhood and I've known her since I was two years old. Taking her on that holiday was important because she was someone I could really confide in, someone from the stable bedrock of my past. I

took out cash using the credit card I shared with Phil - four or five thousand pounds until I reached its limit, visiting ATMs daily to withdraw the full amount possible. I knew he'd cancel the card, but it's interesting to note (and says something about Phil as a person, and his arrogance) that he underestimated me when it came to finance: I don't think he imagined that I would work out how to get money, and so there was a significant delay before my access was blocked. I used the same card to book flights to Ireland for that period of recovery with Cara and her lovely mum.

I did some work at EasyJet (which was therapeutic), and then Rebecca and I set off for Ibiza. We were on a mission to spend money that Phil would have to cover, and I think we did a pretty good job! Oh, we partied! I remember staying in a really good hotel, drinking champagne and going clubbing - David Guetta at Ushuia was a highlight. We visited my friends Patrick and Fiona. They invited Rebecca and me to their Ibiza house and made us lunch, which was lovely. Fiona's a hairdresser and offered to do our hair. We were going for a night out and to watch the sunset at Café Mambo. That was such a caring thing to do. Until Phil's crimes came to light, Patrick and Fiona had been friends of mine and of Phil's; they'd celebrated the 10th anniversary of the business with us. We held a riverboat party on the Thames and Patrick provided the music – he's a well-known DJ on the Ibiza scene. When the two of them saw the evidence against Phil they were furious and distressed, and they took my side.

It was a strange mix of the positive and the negative. I was still stumbling along, trying to process this catastrophe and weighed

down by being so wronged, and for so long. But I was getting things done. I had begun laying the path towards my future, one careful stone at a time.

6

COLLATERAL DAMAGE

This kind of lie never damages only one person, and right from the start I began to realise how many others were caught in the flying rocks.

The co-directors of Phil's business were also his friends. Matt had been a friend since childhood, did the same apprenticeship as Phil and formed the same plans. Phil had carefully poached Richard from another company. While these men did their jobs to the best of their ability, Phil stole from them. He falsified company spending, labelling his personal expenses as 'materials' and using the cash to supply his time abroad, his lavish lifestyle (including a luxury apartment in Vegas) and his fraudulent relationships.

When I found out, I contacted Matt and Richard to show them the facts. We met in the lobby of a central London hotel, Richard's laptop before us. Both men were devastated, but (like so many in this story) they thought about me.

"We've no idea what he might do," Richard said.

"What do you mean?" I asked, still looking at the numbers.

"We don't know who this man *is*. What is he capable of?"

It was dawning on me that Rich meant physical danger. I was shocked, but slowly I nodded, and asked them what they suggested.

I ended up carrying a pepper spray. Phil never did carry out any physical violence, but it's an indication of how traumatic all this was.

"Watch your back," Richard said. The treachery made him ill. It meant that he and I didn't talk much for some years afterwards, but now we *are* in touch, and there is understanding and affection.

So many people had to take time to recover.

Phil's lies stretched a long way. We found that there wasn't even a contract to work in Las Vegas; he'd made that up, and no money was coming from those trips. I was a shareholder in the company and naturally Phil dissolved the business, mostly (I think) to avoid his creditors and the people he'd stolen from. All in all about £500,000 was taken from innocent people.

I hate that he hurt his family. Geoff and Molly, his parents, were horrified. I could feel the physical force of their shock - I remember Geoff weeping. I'd realised quickly that I didn't want his mum finding out the truth from some random person, so I invited her round as soon as I could after the truth came out. My friends, my family, Phil's family and his business partners, were all anxious about my safety. Someone researched the implications of changing the locks, and when we discovered that might not be legal, Phil's brother Jake put bolts and chains on my doors, so I knew where his loyalty lay.

But it's time to talk about the women.

Lara is married to Phil now, and I would love to know the nature of their relationship. That day when I shot off texts to her and to Kate, Lara messaged Phil quickly – I can see their exchange on the iPad screenshots.

I got this. Wtf, Phil!

I can't make out what her attitude is: she seems to jump in to protect him, but I'm not sure:

Shit Phil wot will we do? she writes. **Will I reply saying I haven't seen u in over a yr or just ignore it?**
Fk wats gonna happen?
Shit it needs sorted wat has she found?

Were they in it together? He married her later, so perhaps. Is she rushing in to protect his money? Does she know he's a liar and a serial adulterer, and if so, is she fine with that?

U need to sort it.

Between these messages, Phil says he's 'well and truly fucked'. He tells her not to reply.

I had very little communication with Lara. Later, she sent me a neutral message – sympathetic, I suppose.

In 2019 Naomi, wife of Phil's co-director, sent me screenshots of a London woman photographed with Phil. As with other women their faces are pressed together, and in the background is a festival tent. The texts talk about brunch, and New York City, and he takes her to a Chic concert – oh, the irony! This woman is glamorous, a spokesperson for Asian woman in business, and she's engaged to Phil. I know that it was Kate who managed to warn this woman off so that she never had to suffer Kate's terrible fate.

It's odd - I call these other women 'Las Vegas Lady', 'Belfast Lady', 'London Lady'. I'm respectful. It has never been his partners that I'm angry with. It's him.

Kate's history is much more upsetting and fraught, and it is this part of the story that upsets me the most. My lawyer told me I ought to get the Las Vegas wedding annulled, and that was achieved with the help of Kate's mother – Kate was not responding to communications. I looked back at dates and realised that Kate must have visited the UK in December of 2014. I was visiting friends in Bristol at the time, and Phil erased my presence from the house. Pictures of me were hidden; he even took photographs off the fridge before removing tell-tale magnets, returning them later to make sure I didn't spot changes. Kate told me about all this later. She described how he took a photo of her in front of my Christmas tree, which was hung with Cara's decorations. Kate told me that this made her very uneasy, and when I imagined the scene, I felt sick. Phil asked her not to enter one room, Kate said, saying something about his dad coming to stay. Now I suspect that

all my clothes and my stuff were in that room were. I never stop marvelling at the work he put in!

I believe it was on that occasion, or possibly on another of the occasions when Phil brought Kate to the UK, that he allowed his daughters to meet her. She had brought wedding invitations with her – she told me that. I believe that Phil blackmailed his own children into not mentioning Kate, and I gasp at the cruelty and the abusive nature of involving his children in his lies. After that winter, Dani was quieter and more nervous than before. She doesn't see her father these days very often and neither does Jess.

It was later that same December when Phil was among the passengers on a Virgin Atlantic flight to Vegas when the plane's landing gear failed to engage. The pilot had to make a difficult emergency landing at Gatwick, after forcing the plane to shake in the air to try to dislodge the wheels, and circling repeatedly over Gatwick. Once down, the passengers were taken to an airport hotel, and I wanted to join Phil, but he called Cara and asked her to tell me not to. Miles wondered why at the time – why would a husband not want his wife with him after a brush with death? But now I realise that on the plane he would have been boasting to other passengers that he was off to see his fiancée in Vegas. The last thing he wanted was a *different* wife showing up. It was on that trip, when he finally made it to Vegas, that he got engaged to Kate.

When she got my text that day in June, Kate broke down. She was completely ignorant of his wrongdoing, newly married, and in love. She had photos of a fairy-tale wedding, and a tiny dog they were going to love, too. I see that her experience was different from

mine, and devastating in ways that I cannot imagine. And if I had not found out, it's not impossible that she would never have been so hurt. That comes into my mind – it's inevitable.

As time went by we made a relationship, Kate and I. We might be expected to hate each other - rivals for a man we loved, but it was the opposite: each of us understood the pain that the other was going through. A year after the revelations, a text from Kate read:

> *Sorry for not believing you. I've since found out that everything you said is true, and I've made more discoveries. Can we talk?*

She was a mess and I felt a bond with her, but we dealt with it very differently. I was strong, almost from the moment the earthquake hit, while she was at a different stage of her relationship. I suppose she didn't have the protective gear.

Kate died not long after we talked, just when I was planning to visit her in Vegas. I was aware that she was ill at the time of the wedding, but this was a terrible shock. Her sister texted Phil: *because of you, my sister's dead.* I don't know the full version of events and it's not my business, but we all thought Phil had blood on his hands. The news of her death, a young woman who didn't deserve any of it, affected me very badly. Miles found me grieving as I would for a member of my family.

Who knows how many others there have been, and still are? The impression I get is that he kept a girl in every port, separated by geography in the hope that his cheating would never come to

light. I learned that in South Africa he was seeing a daughter and a mother! But maybe he was lying to women closer at hand … maybe down the road as I write this …

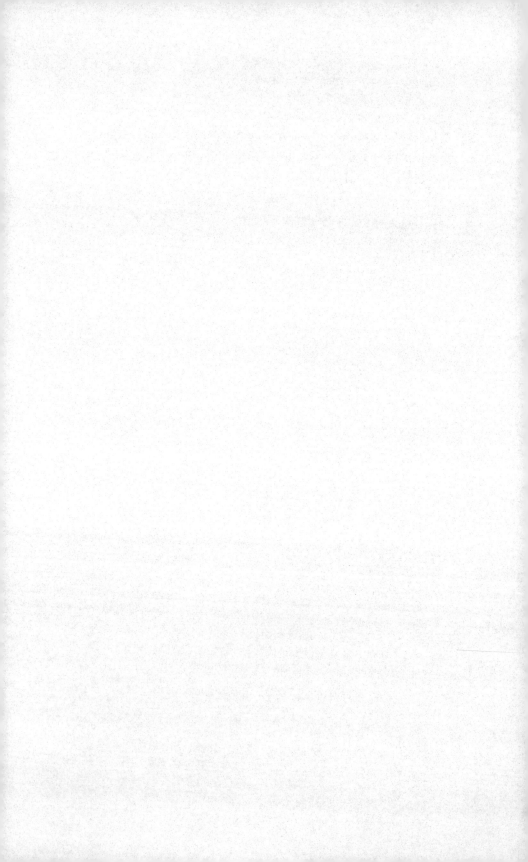

7

HUMANITARIAN AID (1)

M y friends. When I think about them and all that they did for me, I can almost reach out and touch my emotion. Cara has reminded me of the last week of March 2015, when she visited for her birthday. Phil came home from Vegas and was in a terrible mood.

"Everyone wants a piece of me," he growled.

Cara challenged him that day: yes, she said, he was juggling a business, an ex-wife and a busy life, but family had to be the priority. Ten weeks later we knew the appalling reason for his stress: he had probably been moody because he was missing the new wife he'd just married. on March 26th.

Cara set off on my traumatic journey with me, and kept beside me every step of the way. As well as kindness (Cara thinks about others first) she has always offered total honesty and practicality – it's her way. It began in Barbados when we talked about that first clue, the dress receipt. She didn't tell me what to think or what to do. Later when the sky fell on me in June, people pressed their advice and opinions on me, but Cara just faced me in the direction

I needed to go. She called her brother, a police officer, to clarify the legal situation with the second marriage; she wisely suggested an STD check when that had not entered my head; she was worried and asked what money I had, saying that I should gain access to that as soon as I could. I didn't want to; I could *not* accept the contrast between the man I'd married and the one who had just destroyed me, but Cara made me focus. I took £10,000 because any higher sum would have triggered money laundering checks. She was making sure I was safe.

It was Cara, too, who suggested that I delay sending texts to Phil's colleagues and his other women until the right moment. She gave me clarity: if Phil were to find out I knew as *soon* as he landed at Heathrow, he'd have all the time before his arrival at home to take action. He might not come home at all.

But she wasn't just my practical support; she cradled me, too. We shared a bed during those first nights (when the clamour of other people had died away) so that I would not suffer alone. In Ireland she cooperated when I crazily insisted that I *had* to get my nails done. She saw that I needed a little bit of control, a touch of self-esteem when everything was in free-fall. She reminded me recently of the day in Limerick when I mowed her mam's great big lawn, up and down on the ride-on for hours as a kind of therapy. I vividly remember Cara's distress when – also in Ireland – I bought and watched the video of Phil's Vegas wedding. I think there was a link to it in one of the iPad messages, and I used our credit card to pay for it. It was important to me at that moment that he'd notice the purchase listed on the statement, and know that I'd witnessed

his betrayal in all its incredible cruelty. Does it sound sick that I decided to watch? Remember that I was drowning under a flood of nausea; sickness was my whole existence. In the silent, dark, lonely hours before dawn I could not turn the video off, drawn to it like a frantic moth to a flame. There were no tears, only disgust and a kind of numbness. I saw Phil, cool as a cucumber. I saw Kate, so beautiful and so happy. I noticed that none of his friends or family were present, and wondered what intricate lies he'd had to weave to explain that to her. I was lying there with my life crumbling around me, and somewhere there was she, her life being destroyed by his deceit, too. I don't think I slept that night with my stomach churning, waves of acid in my throat and the full impact of what had happened in that video landing on me like an iron weight. Seeing it in moving colour, in stark reality, made me ask the question over and over: how he could go through with it?

In the morning I felt compelled to tell Cara and her mum. I showed Cara the video, expecting her to be angry with me for watching it. The shock and undisguised disgust on her face were terrible, and she cried, sad that I had gone through another heart-shattering experience. She hated that I had been alone when I watched the video and knew what it was doing to me. She confiscated all my devices for my own good!

There were opinions coming in from everyone about what I should do, all of them centred on anger and revenge. Cara looked into my eyes and saw the confusion, and the fact that I had not had a moment to consider what I wanted. She said gently,

"If you want to go back to him, Dee, there is nobody can tell you not to."

She reminded me that the marriage was my marriage, the thoughts my thoughts, and I realised that I had not examined my motivation. On Saturday June 6th, before Cara went home temporarily and before our trip to Ireland, she dropped me at a pub car park while I had a meeting with Phil. I asked to see his phone and he refused. I mentioned my STD test and he said I was being ridiculous. There were no answers he could have given, that day, that would have made me take him back, but I had to push through the fog of confusion, and stamp it on my mind that his crimes were real, to get his reaction and to start making my own decisions. I was able to see him clearly.

Meanwhile, Cara sat and waited for me to come out into the fresh air.

Miles talks about another day when he saw Phil in a pub with a woman, and surreptitiously photographed them on his phone. He admits to a morbid fascination, but he adds that we needed information from a practical point of view: there would be a divorce, and evidence was important.

Miles and I have been drawn together by what we've each experienced, and we have lived our lives in happy parallel since we met and bonded during some crazy training in glamorous Luton! It was Miles who persuaded me to apply for a job at BA.

Miles observed me in the aftermath of the discovery - the way I was coping. He knew that the people clustering around me were supportive, but some had their own motives that grew from

their relationship with Phil. Some had known about aspects of his infidelity before I did, and protected him to a greater or lesser extent. Most stood by me – Neil and Sally could have warned Phil as soon as I got access to the iPad, but they didn't, and Neil cut all ties with Phil. Some of Phil's friends were too appalled to continue any relationship with him. Patrick and Fiona ended their connection to him, for instance. But for some people it was more complicated. Naomi was concerned, I know, about what would happen to the business and to her husband, Matt. It was all understandable, but the atmosphere I was living in was a churning soup of emotion – Miles has called it toxic – constantly revisiting the drama with people who had their own agendas. Miles was brave enough to take responsibility and urge me to move and to find a new direction. I still owned a flat back in Sussex and we could share it once I gave the tenants notice. He had just applied to BA to be able to do more of the exciting, long-haul flying we both loved. He kept me on the phone one day until I finally agreed to apply as well. I was certain I'd never get the job, but I did.

Miles and I have stayed in step. We began work for the ambulance service together in 2020. I hope one day to drive a private ambulance, although - He and I work and play as a team – holidays, good times, the stuff of a great life - and Miles still lives with his boyfriend in the flat we shared during that healing time. I do not know where I'd be without him. Also, Miles didn't know Phil well, and that was probably helpful. He wasn't tangled up with us as a couple, so his focus could be me. It is painful to note that Miles saw a different Phil from the Phil I'd fallen for. He came in fresh,

meeting Phil after I'd been married to him for years and when Phil had already started his spree of betrayal, and he wasn't impressed.

Then there's Alina, my sister, so different from me and yet so loyal. She struggled with Phil right from the start. There were hints that she got, hints I knew about but ignored because I was in love – Phil doing a shoddy plumbing job on my mother's house but increasing his fee unnecessarily (for family …?), Phil keeping his daughters from being at her wedding in 2015. She and I argued just before my wedding to Phil because she felt he wasn't good enough for me, but I wasn't listening. Alina will tell you that I never valued myself enough.

"She gives more than she receives," Alina says. She tells me I'm gorgeous, and that I shouldn't be grateful when people love me because I deserve love. Maybe I listen a little more now, but back then, when Phil sensed her unease and tried to open up space between me and Alina (one of the few people who saw through him), I was blind. It is fascinating to me that my sister's attitude towards Phil mirrors mine. Is that because we're sisters? Both of us veer between two attitudes: saying he doesn't bother us anymore and that we simply don't think about him, and seething anger.

It's good to have had her with me on the road.

8

HUMANITARIAN AID (2)

began to see that I needed a new focus. I became sick of thinking about Phil and talking through what he'd done to me until I was drained.

At the end of the summer I went to Ibiza again to see Patrick and Fiona. It was just for a few days, but they gave me time to recharge. While there I saw a Facebook post from Jude, a friend of 20 years' standing who I'd flown with. Jude and I both loved Greece, and he was posting about the refugee crisis. Syrians and some Afghans were crossing the Aegean from Turkey, landing on Greek islands in their attempt to reach the European mainland and safety. His focus was the island of Leros.

The suffering and desperation broke my heart. Now, having spent time with them, I know the terrible reasons why these refugees had to run, and I know I would have done the same in their situation.

I had a gap between jobs that would last until February 2016, and that seemed like fate. I could go and I could try to help. I could do something real with the time I had.

Jude put me in contact with some locals in Leros. I would have to arrive alone and that was scary, but nothing was going to stop me. I booked my flight and a place to stay (a house that's now like a family home to me). I don't think I even booked the return flight at that point: I don't remember thinking beyond my basic goal.

The port of Leros was chaos. Official organisations *did* arrive after a while (the UNHCR first) but nobody should ever imagine, when they think of a refugee crisis, that there is a well-oiled system or an organised hierarchy. We simply pitched in and provided whatever was needed, as fast as we could, with whatever resources we could find, beg, buy, or call home to the UK for. I got friends and family to donate money via my bank account. It wasn't official: all I could do was assure everyone who contributed that *everything* they gave me would buy more of what the refugees needed. And I negotiated deals on the island with shop owners - for clothes and shoes.

Refugees would reach Farmakonisi first, a smaller island between the Turkish coast and Leros. We called it 'One Biscuit Island' because there they'd be given the absolute minimum. Boats from Leros – mostly owned by volunteers and later some owned by the NGOs – would then set off as soon as the sea was safe, pick people up and bring them back, radioing ahead to warn the crews on Leros. We were divided into 'port crew', which met people off the boats and provided them with the basics, and 'camp crew', and I was mostly at the camp. We had our 'boutique', a hilariously inappropriate word for a place that handed out toothpaste, underwear, soap - whatever was desperately needed.

These supplies were donated from all over but would run out, or we'd realise that something different was required – walking boots for the treacherous onward journey, for instance.

At that time we were preparing refugees to continue via Athens to Macedonia, and then to whatever nation they hoped would be their final destination. The borders were still open then. It might be Germany, Austria, or a range of other countries, though not the UK which was widely understood to be hostile. They would spend about three days at the camp and then board a Blue Star ferry, tickets purchased with the funds they'd managed to take out of Syria. Every three days people would move on, shining lights from the decks as they went, thanking us.

The work demanded that you just kept going. There was no time to stand back and reflect while rescuing human beings. But at the end of each day I'd sit with the other volunteers, and emotion and grief would hit. On our worst day 30 people drowned, and I was familiar with body bags, bereavement experienced close-up, and trauma. There were mothers too damaged by what they had seen to care properly for their babies, so we stepped in. It could be frustrating, for instance when the authorities insisted on loads of bureaucracy when families just needed warmth and shelter, whatever their branch of Islam they happened to be from. The official organisations relied on us, and quite often we ran the place from a practical point of view. We did crazy shifts. I remember once marshalling refugees already at the camp, and keen to help new arrivals, in preparing a marquee while the 'official' organisations prevaricated. A marvellous Dutch charity provided breakfasts,

but there was nobody organising the other meals, so once again we stepped in. I befriended a couple of great UNHCR guys, and they were to become a back-channel, helping me get my hands on resources like wheelchairs and other equipment.

There were *so* many extraordinary people. Alexis, now my friend, had been on the island for a while when I arrived. She was the first person I met after having only phone contact, and she was crucial during my first weeks. Then there was Stacey, never to be forgotten. She and I were the Kim & Aggie of refugee tent cleaning! I have a photo of Stacey and me, and between us is squeezed an angelic little boy. He was the first one to make me cry, and he's my earliest memory of Leros. He was cocky, and helpful, bringing me glasses of water when I was cleaning and making me laugh. When his family got their 'golden tickets' for the ferry, Stacey and I accompanied them to the port. We sat for ages teaching him some English, but when the Blue Star docked, he ran off. I looked around for him as the time for embarking got near, and I found him sobbing.

"You created a *good* memory for him," his mother explained.

There were huge hugs, and I knew I would never forget that boy.

I went home after two and a half months, departing after my planned date because of work that had to be done on the island. My return to a 'real' job was a jolt, and in the short time between coming back from Leros and starting at British Airways, I also moved out of the house I had shared with Phil. A friend house-sat to make sure Phil didn't do anything to it while I was absent.

I had been living among the displaced, handing out shampoo, shoes and food to people I would never see again but who lived in my heart. Complying with the high standards of the BA dress code back home was a challenge!

The plight of the refugees obsessed me when I was in the UK, and I went back to Leros in June 2016. Just before I'd left at the end of my first stay, Matina and Spiros (Greek friends I'd made) had set up a unit for vulnerable families, those with disabilities or illnesses who needed more time before continuing their journey. This 'Pikpa' unit was starting its work when I went back, and I ended helping there, and returning to it whenever I visited the island.

I have so many memories. In October of 2016 I helped out at a sports day for the children organised by the NGO Echo100plus and arranged for all the kids to have ice creams at a friends' café. The photographs from that time are full of gorgeous, smiling children. There is a dark-eyed little girl with her arms around my neck, both of us laughing into the camera, and another where she has her pot of yellow ice-cream clutched in her little hand. There's another of me being kissed by the children. So many bonds were formed and I have so many lives to imagine. There's a book by my very good friend, who I volunteered with in Leros, in which my pseudonym is 'Huggy Lucy', and that's fine with me. I can't pretend that I didn't give a lot of hugs!

There are too many experiences to describe. I only spent a fortnight on Leros with Susie, for instance, but she is now a close friend. Susie came to work with another organisation but the person she was due to work with never showed up. That was the

way things happened – you banded together with other volunteers and just got down to it!

On New Year's Eve Susie and I found two young boys wandering in the camp. We discovered that their auntie had left on the ferry without them, taking their documents with her. Unaccompanied minors could not stay in the camp so we ferried them to a hotel-type building run by Save the Children. I remember driving the car while the boys passed beer bottles back and forth, swigging and enjoying the ride. New Year fireworks were bursting in the black sky above us. Moments like that remain in the memory for a lifetime.

On New Year's Day we learned that some refugees had got stuck on Farmakonisi for several days in the cold. Susie and I were concerned about their welfare, especially because the 'official' teams had decided to take the holiday off. We stayed at the camp all night, Susie using the money she'd brought from home to buy pizza for the new arrivals. Among them was a sick 15-year-old girl who collapsed when she went to the toilet. We had to summon help, and later follow up on her care. The following morning our friend Joachim arrived at the camp and we helped him check the heaters in the tents. We were exhausted – we'd been awake for more than 24 hours by then - but he found us singing 'Good morning, good morning' from *Singin' in the Rain*. The camp residents thought we were hilarious. We dashed away for a two-hour sleep and then drove back. Refugees came out of their tents and crowded round my little hire car, applauding us for sticking by them all night and making sure everyone was okay.

Luckily I also have photos that take me back: in them I see toppling towers of cardboard boxes full of boots, laughing children with their faces painted, me with crazy designs up my arms, drawn by the kids. There are rows of boxy temporary dwellings - in some photos they are tidy and bleak-looking, in later ones they are transformed into a shanty town with washing drying on the roofs. I see real people, all hoping for a new life, all smiling because that is all they can do. I have one picture that is just of bunting - paper cut-outs of people, hanging in a row. Stacey joined me in getting the kids to colour them in, each one different.

Our registered charity, Aegean Solidarity Network Team UK, was founded by Jude in September 2015, after I returned home from my first trip. I became a trustee,and later when I was working at BA, and the team learned about the growing need for toiletries on Leros, I decided to approach management. I knew how undignified it was for the refugees to be given these items piecemeal, bits and pieces in paper cups. Air crew spend half their lives in hotels, of course, and when we put the call out we were deluged with miniatures! I began sending enormous boxes to the island, packed with supplies, and the charity paid the postage on those boxes.

I wanted to do more. My plan was to work part-time at BA, 'camping' in the Sussex flat I shared with Miles, commuting to Leros half the time. But life got in the way - a promotion, meeting Jason in 2018, Covid, the end of flying and the start of a high-pressure job in the ambulance service. Unfortunately, our charity

has had to close down since then, but I'm still proud of what we achieved.

Before I went to Leros I didn't know what I was capable of. I stepped out of my comfort zone in making that trip, and coped with things I never imagined I'd even witness. I think I had seriously underestimated myself in the past. My sister Alina might be able to confirm that! She and Cara have both said since that they worried about me. Miles felt the same, especially when he was the one taking to Stansted for my flight. Sally handed me a weird doorstop thing with an alarm that wakes up its owner if their room door is opened!

Their instincts told them that I'd want to fix things for people and be endlessly kind, and that maybe I'd get walked over, or forget my own safety, or spend my own money. Some of those things did happen, but lending a hand is simply what ordinary people do for one another. It might be helping an old friend in crisis (and my precious friends knew all about doing that!) or it might be helping a new friend who is fleeing for her life across the Aegean, hungry and frightened.

It is just what people do.

Anyway, the change and the distraction were good for me, both physically and emotionally. I had been made to feel worthless by Phil, and Leros helped me to see that I wasn't.

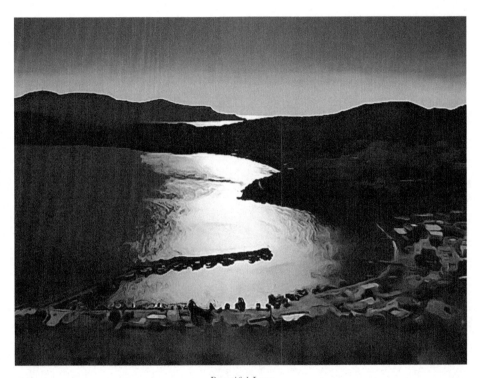

Beautiful Leros

The Leros refugee camp, 2015/2016

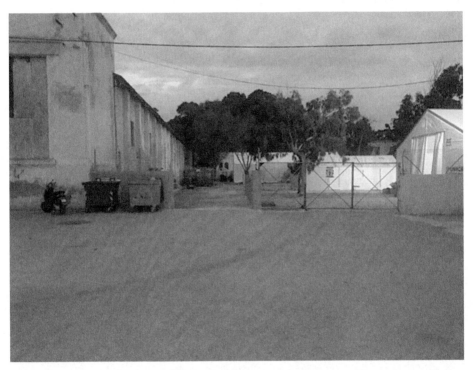

The Leros refugee camp, 2015/2016

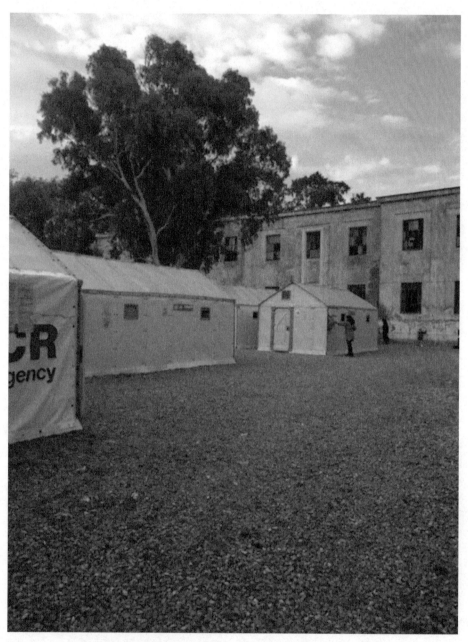

The Leros refugee camp, 2015/2016

The Leros refugee camp, 2015/2016

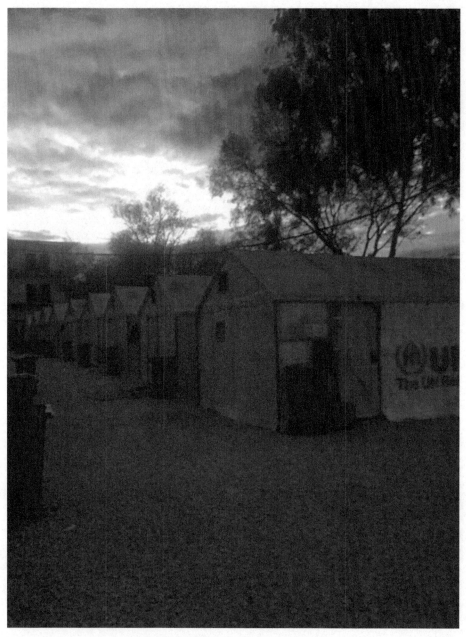

The Leros refugee camp at dusk, 2015

The view from my room in Leros - my second home

Donations for the refugees are held in storage before being distributed

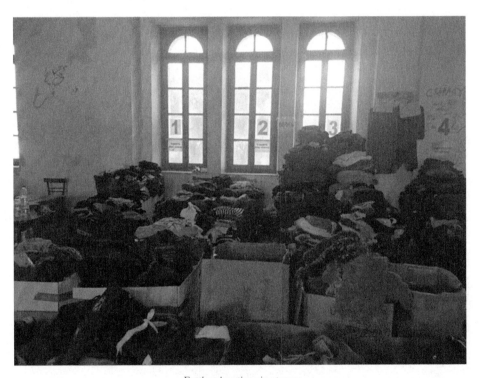

Further donations in storage

This was the hub for vulnerable families and children. Sadly it is now closed.

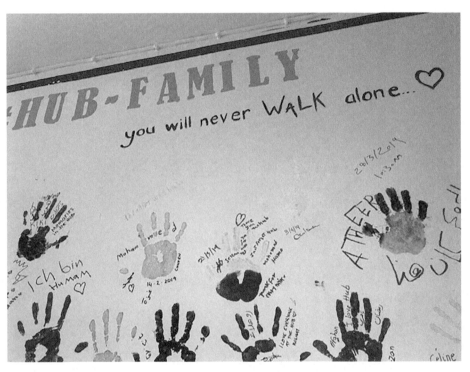

These were handprints of refugees that passed through the social and educational
hub set up by Echo100plus

This is when we did arts and crafts with the refugee children - they were so proud
of their decorations

Artwork on display at the refuge for vulnerable families and children

Leros beach

Leros at sunset

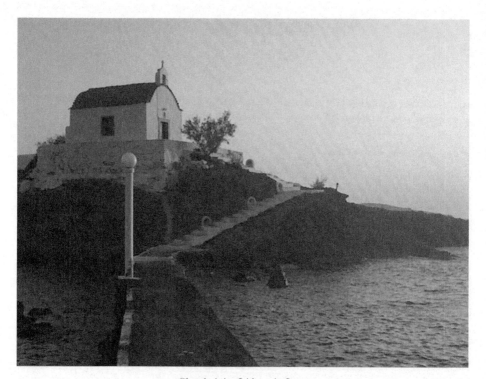

Church Agios Isidoros in Leros

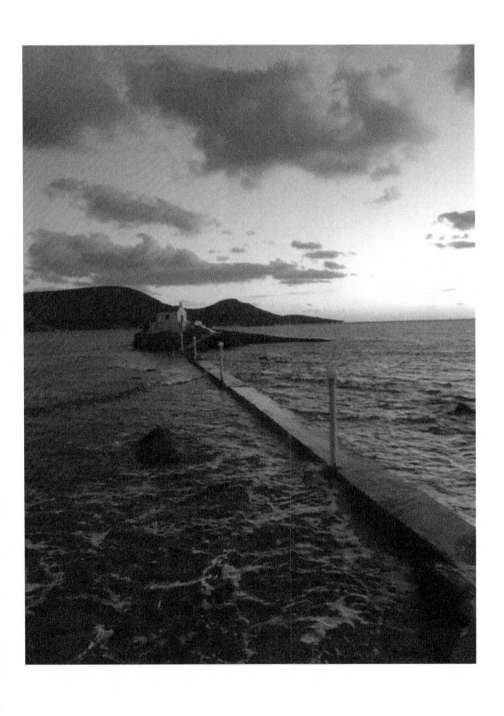

9

FAULT LINE

He has lurked behind this story for too long. Now is the time to bring the man at the centre of all this out into the limelight. Each disaster has a point of origin – the shifting of the Earth's plates under the ocean, the brewing of a riot on a hot summer's night, a virus passing silently to its first human carrier.

In the final analysis Phil was the creator of it all.

What made him so self-absorbed and so happy to hurt? I suppose he can't be mentally well, not entirely, and I pity him for that. It's been suggested that he's a narcissist, and maybe that's true. Many men cheat – women too – but Phil's special method was to build whole relationships that he knew stood on shifting sand, and to betray multiple women with elaborate structures of pretended loyalty and false promises. He wasn't just after easy extra-marital sex. He seems to crave adoration, and a woman who loves him and believes he belongs to her and she to him. He wants complex relationships that make him feel … I don't know … like a hero?

We had a good marriage, but I don't know how he felt about me during that marriage, and that's torture. Was I like another glass

of champagne or expensive watch - another good looking, well-groomed woman on his arm? I don't know.

Phil's behaviour didn't come from his childhood; he doesn't have that excuse. There was no abuse there, no lasting damage to make us feel sorry for him. He didn't know his natural father, but his stepfather raised him from four months old. His mum offered to tell him the name of his biological father, but Phil didn't feel he needed that. He had a father who gave him everything a child needs. He has a brother, Jake, who is lovely – a kind, genuine, family man. His parents are wonderful, and it means a lot that they are like a second mother and father to me. I know that Jake struggled to like Phil, and that his parents worried about him. They found his 'flash Harry' ways distasteful and they couldn't work out why he was like that, always wanting to impress with money or possessions.

He had the same start as Matt and the same working life. Somewhere along the line, however, Phil decided that he was going to shine, but through lies, greed and betrayal. The aftermath of his financial perfidy rumbled on for a long time. By October 2017, when the divorce was finally through, I was broke. At one stage I applied to StepChange, the debt charity. I remember standing in tears at the back of an aircraft because I just didn't know what to do. I knew the business was gone and I had no way to get my shares, or any other source of funds. He had stopped paying tax on our flat and I had to stump up for that. It angers me that I gave up fighting. It had become too much; I had to cut and run. The sale of our house covered my solicitor's fees. Phil had to pay me what he owed in the settlement, and for years he sent me £250 a month,

claiming he couldn't afford more. I'm still astonished at this, some time after the debt was finally cleared. He *couldn't afford more?* I look at the lifestyle he has now, and I look at mine, and I wonder why I ever swallowed this crap. But that's what happens when someone batters you into submission. I stood up for as much as I could, for as long as I could, but there is only so much energy that a person has.

There is a moment that has haunted me ever since. It was the day he went to Las Vegas for the final time before I found out, and he came into our bedroom when I was drinking a mug of tea.

"*Please* let this be the last time," I said.

He looked directly at me. I can only say that his expression was sorrowful, as though somehow he did want to stop hurting me. It was as though he knew, somewhere inside, that he was doing a terrible wrong.

I don't know the full extent of Phil's wrongdoing and I never will, but there are suspicions so dark that I find them hard to write down. In 2013 Phil organised a trip to Vegas with other couples, among them Neil and Sally, and Matt and Naomi. Phil got us VIP tickets - a private booth to see the DJ David Guetta at the Encore XS Hotel, with all the drinks we wanted! Earlier that same evening we'd seen Boyz II Men at another theatre; it was an extraordinary night and I was beside myself with excitement because I was a huge fan of Mr Guetta. He wasn't due to play until 1am so I told myself to be sensible and limit my alcohol intake, or waste the opportunity. I'd had only had one drink when I felt strange. Putting it down to jet lag I made an excuse and nipped to the loo. Thank God my

friend Jill needed to go too, because on the way I felt my arms and legs going numb.

"Can we stop, Jill?" I asked her.

We were near the hotel pool and so I sat and dangled my legs in the cool water. Then I just passed out.

I could hear Sally talking to me - she was a nurse at the time - but I couldn't move my limbs; I couldn't even move my eyes, or respond to her questions. Later I sat in a back room of the Encore in a wheelchair, feeling dreadful, waiting with my friends for an ambulance to the ER, where medics said they thought my drink had been spiked.

I can see Phil now, standing distant from me in a doorway of that back room, on his phone. He was due to leave Las Vegas early. Normally that would have been okay, but he stuck to his schedule even though I was unwell, and left me lonely. I wanted to go home, of course, but more than that I wanted to travel with my husband. But that didn't happen. I believe he abandoned me because his plan was to go to Lara. I recall the image of that phone in his hand and I believe he was speaking to her.

But the worst of it is the dark, lurking suspicion that he found a way to make sure I didn't travel with him. The friends who were there believe that he was the person who spiked my drink.

Perhaps I should have noticed that people were uneasy about my husband – a few too many people who cared about me. But I loved him, and we were happy, and who would really listen to those hints? My mum didn't like Phil but she came around. I think she felt she should, for me. Naomi, Matt's wife, was the same, but made efforts

to get along. I recall Phil trying to engineer trouble between me and Naomi. He knew that she was watching him, and wondering.

Family and friends were loving me and caring about me. But it only takes one person who doesn't care, to bring destruction.

What can I say about him that I can be sure of? That he worked hard at deception! I'll give him that much. Hiding that much cheating must have been exhausting, and now I understand why he was stressed for so much or our marriage, and why a vein used to pulse sometimes in his forehead, and a stress itch would make him scratch. Miles describes an occasion when Phil was weirdly distant from him, and I think he saw the threat that my friends posed (maybe especially another male). Being in the same room as someone who loved me brought his cruelty to the front of his mind, and he didn't like that. It was the same with Naomi, Matt's wife – the way he tried to separate her from me. He needed me isolated in his world view, so his guilt wouldn't be so heavy.

He was manipulating several women at once, maintaining a delicate web that might stretch at any moment and snap. He watched his web, until I hacked his iPad and brought it down. Remember that he betrayed not only the women in his life, but his friends and business partners, too. It takes a particular kind of person to do that, and there's no way I can get inside that kind of mind.

10

THE FUTURE

I am still hurt, and I still hate him. If it were not for his daughters, and his lovely family, I would snatch that rug out from under him again in whatever way I could. We all want to leave anger behind us and say, 'Oh him - he's nothing.' But we can't help searching for fuel for our fire. I have fanned the flames of resentment, but I know that's natural. It will not hold me back.

I won't marry again. Jason is wonderful, my rock, and has restored my faith that there are good men out there. But for me, Phil made a mockery of the institution of marriage. I don't need to marry someone to show that I love them. From a pragmatic point of view, marriage can suck resources out of you if you are betrayed. I have no secrets from my partner but I am financially independent and always will be. I'm still a romantic at heart, but my defences are strong – practicality, thoughtfulness, knowing my own mind. There's a circle that I have placed around myself, and there is also a circle I have placed around the people I want to protect, from my step-daughters to my former parents-in-law to the women I barely knew but who suffered as I did. Sometimes I worry about

the women he damaged, and may still be damaging: have I caused any hurt? But I know that I had no choice.

As for Phil, he stands way, way outside my circles.

The woman I am today has picked herself up from the rubble and the debris, shaken off the cloying dust, and lifted her chin towards the sky. I'm honest and I'm confident, though it took me a long time to get to this place. Without my inner resources, and the inspiration of the friends & family who stood by me, I would never be the woman I am today.

My light shines on.

Postscript

This book would not have been written but for a special moment in a hairdressing salon. I used to fly with Nerissa, but by 2021 she was working in hair and beauty, and being in the salon where she worked had been a sort therapy for me for some time, chatting and sharing with some great women. One afternoon I was telling my story. Erin my hairdresser was there, and Simone the owner, plus Nerissa and a young hairdresser, Chloe. Chloe practically yelled,

"But you have got to make this into a book!"

Nerissa said she was absolutely right; Erin and Simone agreed. Other people had said that this story was big and extraordinary enough for a novel, but until then I hadn't taken the idea seriously. Those women, in that safe and nurturing place - they were my encouragement.

And here it is.

Story Terrace

Printed in Great Britain
by Amazon

13510934R00054